deficeret aut quibus ins...

...d huic cognoscenda, priusquam periculum...

mandat ut exploratis omnibus rebus ad se quam...

quod inde erat brevissimus in Britanniam traiectus. huc nav...

Veneticum bellum fecerat classem iubet convenire. interim consilio eius cogni...

...ribus eiusque civitatibus ad eum legati veniunt, qui polliceantur obsides dare atq...

...perare. quibus auditis liberaliter pollicitus hortatusque ut in ea sententia permaneren...

iis una Commium, quem ipse Atrebatibus superatis regem ibi constituerat, cuius et virtute...

...uem sibi fidelem esse arbitrabatur cuiusque auctoritas in his regionibus magni habe...

...s possit adeat civitates horteturque et populi Romani fidem sequantur, seque celeri...

...enus perspectis quam plurimis regionibus, quantum ei facultatis dari potuit qui navi...

e non auderet, quinto die ad Caesarem revertitur quaeque ibi perspexisset renuntiat.

...vium parandarum causa moratur, ex magna parte Morinorum ad eum legati vene...

...emporis consilio excusarent, quod homines barbari et nostrae consuetudinis imperiti b...

...ent, seque ea quae imperasset facturos pollicerentur. hoc sibi Caesar satis opportune accid...

...rum rerum occupationes Britanniae anteponendas indicabat, magnum iis numerum o...

...rgum hostem relinquere volebat neque belli gerendi propter anni tempus facultatem h...

dductis eos in fidem recipit. Navibus circiter octoginta onerariis coactis contractisque...

...nsportandas legiones existimabat, quicquid praeterea navium longarum habebat, id quae...

...tribuit. huc accedebant XVIII onerariae naves, quae ex eo loco a milibus passuum octo ver...

...ndem portum venire possent; has equitibus tribuit. reliquum exercitum Q. Titurio Sabin...

...n Menapios atque in eos pagos Morinorum a quibus ad eum legati non venerant ducendu...

...rum legatum cum eo praesidio quod satis esse arbitrabatur portum tenere iussit. His...

...ia rem ad navigandum tempestatem tertia fere vigilia naves solvit equitesque in ulter...

...aves conscendere et se sequi iussit. a quibus cum paulo tardius esset administratum, eorum...

...interim inciderat et adversis ventis retinebantur. ipse hora diei circiter quarta cum primi...

...angustis mare continebatur, uti ex superioribus in litus telum adigi posset. hunc a...

...locum arbitratus, dum reliquae naves eo convenirent, ad horam nonam in ancoris exspec...

...que militum convocatis et quae ex Voluseno cognovisset et quae fieri vellet ostendit monu...

...aximeque ut maritimae res postularent, ut quae celerem atque instabilem motum haberen...

...omniaque ab iis administrarentur. his dimissis et ventum et aestum uno tempore nactus...

...blatis ancoris circiter milia passuum septem ab eo loco progressus aperto ac plano lito...

...ri consilio Romanorum cognito, praemisso equitatu et essedariis, quo plerumque genere...

...c copiis subsecuti nostros navibus egredi prohibebant. erat ob has causas summa diff...

...ci in alto constitui non poterant, militibus autem ignotis locis, impeditis...

...de navibus desiliendum et in fluctibus consistendum et cum...

...rum progressi omnibus membris expeditis notissim...

...erriti atque huius omnino generi...

...utebantur...

...editior...

of the said Mayhank And also of all those three other Messuages Cottages Tenements and Hereditaments of said Richard Curtis and John Mayhank And of all ways lights Easements and singular the said premises hereinbefore mentioned belonging or in any wise appertaining (The whole of the said Thomas Brown and Elizabeth his wife (both now deceased) of and from Joshua Banford the younger and Elizabeth his wife of the said Thomas Brown to the only use and Behoof of the said Thomas Brown and Elizabeth his wife and of the said Elizabeth his wife (after his decease) unto his son Thomas Brown out of the said Thomas Brown (after his said wife's decease) unto his several heirs of the said Estate will and Estate of the said Thomas Brown and John Brown deceased and his several heirs and Richard Brown unto his Brothers the said ffrancis Brown Richard Brown and to the ffreehold premises in the said undivided two thirds or half parts thereof by towards Brown hath her power in the said undivided two thirds or half part thereof by towards) And of the said premises hereinbefore mentioned and every part thereof with the Appurtenants And also all the Estate interest of them the said Mary Brown and John Brown party hereto in and to the same together with the any part thereof now in the hands custody or power of the said Mary Brown and John Brown party hereto two or equity To have and to hold the said several Messuages or half part of the said several premises unto the said ffrancis Brown his heirs and assigns to the only proper use and behoof of the said premises by and under the heirs and assigns the several due and of right arising of the free estate of the premises by and under the heirs and assigns the several due and of right arising and Administrators both covenant promise and grant to and with the said ffrancis Brown his heirs and Mary Brown and John Brown party hereto now are the true and lawful owners of the said undivided two thirds hereto is the true of now in his own right of a good sure pure absolute and indefeasible Estate of inheritance in his heirs and assigns in his own right of a good sure pure absolute and indefeasible Estate of inheritance two good right full power and lawful and absolute Authority to grant bargain sell aliene release and convey the said premises hereto his and their only proper use and behoof as aforesaid And further that me and at all times forever hereafter peaceably and quietly have hold use occupy possess and enjoy the without any lett trouble eviction denial interruption or ejectment of them the said Mary Brown or assigns ffree and discharged or otherwise well and sufficiently saved harmless and kept indemnified by the said from against all former and other gifts grants Bargains sales Leases Mortgages Jointures Dowers uses wills and against all statutes gifts grants bargains sales and also statutes Recognisances Judgments Executions ffines sales obligatory statutes whatsoever and of the Staple or otherwise troubles and all manner of Incumbrances whatsoever unto issue or suffer to be had made committed or done or do be had made committed or done or any persons or persons whatsoever of their the said John Brown party hereto or any persons or persons whatsoever

of Thomas Maybank and also of all those three other Messuages or Cottages and their
of Broad Dinks to William Bain Smith and Richard Curtis and John Maybank and of all ways lights easements or
singular the said premises hereinbefore mentioned belonging or in anywise appertaining (the whole of a
own and Elizabeth his wife (both now deceased) of and from both of the said Thomas Brown and Elizabeth his wife
of the said Thomas Brown to the only use and behoof of the said Thomas Brown and Elizabeth his wife
he last will and testament of the said Thomas Brown deceased (after his said Wife's decease) unto his son Thomas
of hereby devised to his brothers the said Thomas Brown and John Brown deceased and their several heirs f
of Thomas Brown and John Brown party hereto are by virtue of the said devise Tenants in tail to the f
ry Brown hath her dower in the said unmarried Mary or half part thereof hereby conveyed) And of the several
he premises hereinbefore mentioned and every part thereof with the appurtenants and also all the estate
latter part thereof unto the said Mary Brown and John Brown party hereto in and to the same together with
any part thereof unto the said Mary Brown and John Brown party hereto
no or equity To have and to hold the said messuages dwelling or power of the said Mary Brown party hereto
ments unto the said Thomas Brown his heirs and assigns to the only proper use and of right at all
of the free office of the premises by and under the rights and streets hereto due and of right at all
no administrators of the said Thomas Brown his heirs and with the said Mary Brown his heirs and
rry Brown and John Brown party hereto now are the true and lawful owners of the said messuages and
hereto is hereof urged in his own right of a good sure pure absolute and indefeasible estate of inheritance
or other lawful matter or thing to alter charge determine defeat or make void the same And also that
uses good right full power and absolute lawful and absolute Authority to grant bargain sell alien
n his heirs and assigns to his and their only proper use and behoof as aforesaid to have hold use occupy possess and enjoy his
ne and at all times forever hereafter peaceably and quietly have hold use occupy possess and enjoy his
without any hindrance troubles and disturbance interruption or denial of them the said Mary Brown Jo
or assigns freed and discharged or otherwise acquitted and kept harmless and indemnified by the said Ja
against all former and other gifts grants bargains sales leases Mortgages Jointures dower liss Wills
obligatory statuts recognizances extents Judgments Executions rents arrears
fincumbrances whatsoever without any to issue or suffer so to be had made committed done
us of them the said John Brown party hereto or any persons (Brown whose

Quod cū audisset dauid: descendit in presidiū. Philistijm autem venientes diffusi sunt in valle raphaim. Et cōsuluit dauid dūm dicens. Si ascendā ad philistijm·et si dabis eos ī manu mea? Et dixit dūs ad dauid. Ascende: qa tradens dabo philistijm in manu tua. Venit ergo dauid ad baalpharasim: et percussit eos ibi et dixit. Diuisit dūs inimicos meos corā me: sicut diuidunt aque. Propterea vocatū e nomen loci illi9 baalpharasim. Et reliqrunt ibi sculptilia sua: q tulit dauid et viri ei9. Et addiderunt adhuc philistiim ut ascenderent: et diffusi sūt ī valle raphaim. Cōsuluit autē dauid dūm. Si ascendā cōtra philisteos: z tradas eos in manus meas? Qui rūdit. Nō ascendas cōtra eos sed gira post tergū eorū: z venies ad eos exaduso pirorū. Et cū audieris sonitū clamoris gradientis ī cacumie piror tūc inibis pliū: qa tūc egredict dūs āte faciē tuā: ut p=

Quod cū audisset dauid: descendit in presidiū. Philistijm autem venientes diffusi sunt in valle raphaim. Et cōsuluit dauid dūm dicens. Si ascendā ad philistijm·et si dabis eos ī manu mea? Et dixit dūs ad dauid. Ascende: qa tradens dabo philistijm in manu tua. Venit ergo dauid ad baalpharasim: et percussit eos ibi et dixit. Diuisit dūs inimicos meos corā me: sicut diuidunt aque. Propterea vocatū e nomen loci illi9 baalpharasim. Et reliqrunt ibi sculptilia sua: q tulit dauid et viri ei9. Et addiderunt adhuc philistiim ut ascenderent: et diffusi sūt ī valle raphaim. Cōsuluit autē dauid dūm. Si ascendā cōtra philisteos: z tradas eos in manus meas? Qui rūdit. Nō ascendas cōtra eos sed gira post tergū eorū: z venies ad eos exaduso pirorū. Et cū audieris sonitū clamoris gradientis ī cacumie piror tūc inibis pliū: qa tūc egredict dūs āte faciē tuā: ut p=

Quod cū audisset dauid: descendit in presidiū. Philistijm autem venientes diffusi sunt in valle raphaim. Et cōsuluit dauid dūm dicens. Si ascendā ad philistijm·et si dabis eos ī manu mea? Et dixit dūs ad dauid. Ascende: qa tradens dabo philistijm in manu tua. Venit ergo dauid ad baalpharasim: et percussit eos ibi et dixit. Diuisit dūs inimicos meos corā me: sicut diuidunt aque. Propterea vocatū e nomen loci illi9 baalpharasim. Et reliqrunt ibi sculptilia sua: q tulit dauid et viri ei9. Et addiderunt adhuc philistiim ut ascenderent: et diffusi sūt ī valle raphaim. Cōsuluit autē dauid dūm. Si ascendā cōtra philisteos: z tradas eos in manus meas? Qui rūdit. Nō ascendas cōtra eos sed gira post tergū eorū: z venies ad eos exaduso pirorū. Et cū audieris sonitū clamoris gradientis ī cacumie piror tūc inibis pliū: qa tūc egredict dūs āte faciē tuā: ut p=

dā tradens dabo philistijm in manu mea? Et dixit dūs ad dauid. Ascede: ad philistijm·et si dabis eos ī manu suluit dauid dūm dicens. Si ascendā diffusi sunt in valle raphaim. Et cō presidiū. Philistijm autem venientes Quod cū audisset dauid: descendit in

Quod cū audisset dauid: descendit in presidiū. Philistijm autem venientes diffusi sunt in valle raphaim. Et cōsuluit dauid dūm dicens. Si ascendā ad philistijm·et si dabis eos ī manu mea? Et dixit dūs ad dauid. Ascende: qa tradens dabo philistijm in manu tua. Venit ergo dauid ad baalpharasim: et percussit eos ibi et dixit. Diuisit dūs inimicos meos corā me: sicut diuidunt aque. Propterea vocatū e nomen loci illi9 baalpharasim. Et reliqrunt ibi sculptilia sua: q tulit dauid et viri ei9. Et addiderunt adhuc philistiim ut ascenderent: et diffusi sūt ī valle raphaim. Cōsuluit autē dauid dūm. Si ascendā cōtra philisteos: z tradas eos in manus meas? Qui rūdit. Nō ascendas cōtra eos sed gira post tergū eorū: z venies ad eos exaduso pirorū. Et cū audieris sonitū clamoris gradientis ī cacumie piror tūc inibis pliū: qa tūc egredict dūs āte faciē tuā: ut p=

Quod cū audisset dauid: descendit in presidiū. Philistijm autem venientes diffusi sunt in valle raphaim. Et cōsuluit dauid dūm dicens. Si ascendā ad philistijm·et si dabis eos ī manu mea? Et dixit dūs ad dauid. Ascende: qa tradens dabo philistijm in manu tua. Venit ergo dauid ad baalpharasim: et percussit eos ibi et dixit. Diuisit dūs inimicos meos corā me: sicut diuidunt aque. Propterea vocatū e nomen loci illi9 baalpharasim. Et reliqrunt ibi sculptilia sua: q tulit dauid et viri ei9. Et addiderunt adhuc philistiim ut ascenderent: et diffusi sūt ī valle raphaim. Cōsuluit autē dauid dūm. Si ascendā cōtra philisteos: z tradas eos in manus meas? Qui rūdit. Nō ascendas cōtra eos sed gira post tergū eorū: z venies ad eos exaduso pirorū. Et cū audieris sonitū clamoris gradientis ī cacumie piror tūc inibis pliū: qa tūc egredict dūs āte faciē tuā: ut p=

Quod cū audisset dauid: descendit in presidiū. Philistijm autem venientes diffusi sunt in valle raphaim. Et cōsuluit dauid dūm dicens. Si ascendā ad philistijm·et si dabis eos ī manu mea? Et dixit dūs ad dauid. Ascende: qa tradens dabo philistijm in manu tua. Venit ergo dauid ad baalpharasim: et percussit eos ibi et dixit. Diuisit dūs inimicos meos corā me: sicut diuidunt aque. Propterea vocatū e nomen loci illi9 baalpharasim. Et reliqrunt ibi sculptilia sua: q tulit dauid et viri ei9. Et addiderunt adhuc philistiim ut ascenderent: et diffusi sūt ī valle raphaim. Cōsuluit autē dauid dūm. Si ascendā cōtra philisteos: z tradas eos in manus meas? Qui rūdit. Nō ascendas cōtra eos sed gira post tergū eorū: z venies ad eos exaduso pirorū. Et cū audieris sonitū clamoris gradientis ī cacumie piror tūc inibis pliū: qa tūc egredict dūs āte faciē tuā: ut p=

Quod cū audisset dauid: descendit in presidiū. Philistijm autem venientes diffusi sunt in valle raphaim. Et cōsuluit dauid dūm dicens. Si ascendā ad philistijm·et si dabis eos ī manu mea? Et dixit dūs ad dauid. Ascende: qa tradens dabo philistijm in manu tua. Venit ergo dauid ad baalpharasim: et percussit eos ibi et dixit. Diuisit dūs inimicos meos corā me: sicut diuidunt aque. Propterea vocatū e nomen loci illi9 baalpharasim. Et reliqrunt ibi sculptilia sua: q tulit dauid et viri ei9. Et addiderunt adhuc philistiim ut ascenderent: et diffusi sūt ī valle raphaim. Cōsuluit autē dauid dūm. Si ascendā cōtra philisteos: z tradas eos in manus meas? Qui rūdit. Nō ascendas cōtra eos sed gira post tergū eorū: z venies ad eos exaduso pirorū. Et cū audieris sonitū clamoris gradientis ī cacumie piror tūc inibis pliū: qa tūc egredict dūs āte faciē tuā: ut p=

Quod cū audisset dauid: descendit in presidiū. Philistijm autem venientes diffusi sunt in valle raphaim. Et cōsuluit dauid dūm dicens. Si ascendā ad philistijm: et si dabis eos ī manu mea? Et dixit dūs ad dauid. Ascende: qa tradens dabo philistijm in manu tua. Venit ergo dauid ad baalpharasim: et percussit eos ibi et dixit. Diuisit dūs inimicos meos corā me: sicut diuidunt aque. Propterea vocatū e nomen loci illi⁹ baalpharasim. Et reliqrunt ibi sculptilia sua: q tulit dauid et viri ei⁹. Et addiderunt adhuc philistijm ut ascenderent: et diffusi sūt ī valle raphaim. Cōsuluit autē dauid dūm. Si ascendā cōtra philisteos: z tradas eos in manus meas? Qui rūdit. Nō ascendas cōtra eos sed gira post tergū coru: z venies ad eos exadūso piroru. Et cū audieris sonitū clamoris gradictis ī cacumie piror tūc imbis pliu: qa tūc egrediet dūs āte faciē tuā: ut p

Quod cū audisset dauid: descendit in presidiū. Philistijm autem venientes diffusi sunt in valle raphaim. Et cōsuluit dauid dūm dicens. Si ascendā ad philistijm: et si dabis eos ī manu mea? Et dixit dūs ad dauid. Ascende: qa tradens dabo philistijm in manu tua. Venit ergo dauid ad baalpharasim: et percussit eos ibi et dixit. Diuisit dūs inimicos meos corā me: sicut diuidunt aque. Propterea vocatū e nomen loci illi⁹ baalpharasim. Et reliqrunt ibi sculptilia sua: q tulit dauid et viri ei⁹. Et addiderunt adhuc philistijm ut ascenderent: et diffusi sūt ī valle raphaim. Cōsuluit autē dauid dūm. Si ascendā cōtra philisteos: z tradas eos in manus meas? Qui rūdit. Nō ascendas cōtra eos sed gira post tergū coru: z venies ad eos exadūso piroru. Et cū audieris sonitū clamoris gradictis ī cacumie piror tūc imbis pliu: qa tūc egrediet dūs āte faciē tuā: ut p

Quod cū audisset dauid: descendit in presidiū. Philistijm autem venientes diffusi sunt in valle raphaim. Et cōsuluit dauid dūm dicens. Si ascendā ad philistijm: et si dabis eos ī manu mea? Et dixit dūs ad dauid. Ascende: qa tradens dabo philistijm in manu tua. Venit ergo dauid ad baalpharasim: et percussit eos ibi et dixit. Diuisit dūs inimicos meos corā me: sicut diuidunt aque. Propterea vocatū e nomen loci illi⁹ baalpharasim. Et reliqrunt ibi sculptilia sua: q tulit dauid et viri ei⁹. Et addiderunt adhuc philistijm ut ascenderent: et diffusi sūt ī valle raphaim. Cōsuluit autē dauid dūm. Si ascendā cōtra philisteos: z tradas eos in manus meas? Qui rūdit. Nō ascendas cōtra eos sed gira post tergū coru: z venies ad eos exadūso piroru. Et cū audieris sonitū clamoris gradictis ī cacumie piror tūc imbis pliu: qa tūc egrediet dūs āte faciē tuā: ut p

Quod cū audisset dauid: descendit in presidiū. Philistijm autem venientes diffusi sunt in valle raphaim. Et cōsuluit dauid dūm dicens. Si ascendā ad philistijm: et si dabis eos ī manu mea? Et dixit dūs ad dauid. Ascende: qa tradens dabo philistijm in manu tua. Venit ergo dauid ad baalpharasim: et percussit eos ibi et dixit. Diuisit dūs inimicos meos corā me: sicut diuidunt aque. Propterea vocatū e nomen loci illi⁹ baalpharasim. Et reliqrunt ibi sculptilia sua: q tulit dauid et viri ei⁹. Et addiderunt adhuc philistijm ut ascenderent: et diffusi sūt ī valle raphaim. Cōsuluit autē dauid dūm. Si ascendā cōtra philisteos: z tradas eos in manus meas? Qui rūdit. Nō ascendas cōtra eos sed gira post tergū coru: z venies ad eos exadūso piroru. Et cū audieris sonitū clamoris gradictis ī cacumie piror tūc imbis pliu: qa tūc egrediet dūs āte faciē tuā: ut p

Quod cū audisset dauid: descendit in presidiū. Philistijm autem venientes diffusi sunt in valle raphaim. Et cōsuluit dauid dūm dicens. Si ascendā ad philistijm: et si dabis eos ī manu mea? Et dixit dūs ad dauid. Ascende: qa tradens dabo philistijm in manu tua. Venit ergo dauid ad baalpharasim: et percussit eos ibi et dixit. Diuisit dūs inimicos meos corā me: sicut diuidunt aque. Propterea vocatū e nomen loci illi⁹ baalpharasim. Et reliqrunt ibi sculptilia sua: q tulit dauid et viri ei⁹. Et addiderunt adhuc philistijm ut ascenderent: et diffusi sūt ī valle raphaim. Cōsuluit autē dauid dūm. Si ascendā cōtra philisteos: z tradas eos in manus meas? Qui rūdit. Nō ascendas cōtra eos sed gira post tergū coru: z venies ad eos exadūso piroru. Et cū audieris sonitū clamoris gradictis ī cacumie piror tūc imbis pliu: qa tūc egrediet dūs āte faciē tuā: ut p

Quod cū audisset dauid: descendit in presidiū. Philistijm autem venientes diffusi sunt in valle raphaim. Et cōsuluit dauid dūm dicens. Si ascendā ad philistijm: et si dabis eos ī manu mea? Et dixit dūs ad dauid. Ascende: qa tradens dabo philistijm in manu tua. Venit ergo dauid ad baalpharasim: et percussit eos ibi et dixit. Diuisit dūs inimicos meos corā me: sicut diuidunt aque. Propterea vocatū e nomen loci illi⁹ baalpharasim. Et reliqrunt ibi sculptilia sua: q tulit dauid et viri ei⁹. Et addiderunt adhuc philistijm ut ascenderent: et diffusi sūt ī valle raphaim. Cōsuluit autē dauid dūm. Si ascendā cōtra philisteos: z tradas eos in manus meas? Qui rūdit. Nō ascendas cōtra eos sed gira post tergū coru: z venies ad eos exadūso piroru. Et cū audieris sonitū clamoris gradictis ī cacumie piror tūc imbis pliu: qa tūc egrediet dūs āte faciē tuā: ut p

Quod cū audisset dauid: descendit in presidiū. Philistijm autem venientes diffusi sunt in valle raphaim. Et cōsuluit dauid dūm dicens. Si ascendā ad philistijm: et si dabis eos ī manu mea? Et dixit dūs ad dauid. Ascende: qa tradens dabo philistijm in manu tua. Venit ergo dauid ad baalpharasim: et percussit eos ibi et dixit. Diuisit dūs inimicos meos corā me: sicut diuidunt aque. Propterea vocatū e nomen loci illi⁹ baalpharasim. Et reliqrunt ibi sculptilia sua: q tulit dauid et viri ei⁹. Et addiderunt adhuc philistijm ut ascenderent: et diffusi sūt ī valle raphaim. Cōsuluit autē dauid dūm. Si ascendā cōtra philisteos: z tradas eos in manus meas? Qui rūdit. Nō ascendas cōtra eos sed gira post tergū coru: z venies ad eos exadūso piroru. Et cū audieris sonitū clamoris gradictis ī cacumie piror tūc imbis pliu: qa tūc egrediet dūs āte faciē tuā: ut p

Sappi lettor dignissimo, che le lettere cancellaresche sono de diuerse qualita di corpi, aste, legature, & incatenature, torture, dritte tonde & nõ tonde, trattizate & senza tratti, & altri sentimẽti de altre nature come hai potuto uedere nelle scritte qualita de lettere, le quali si usano nelle cancellarie de tutte le cita della Italia, & doue si costuma una qualita, e doue una tra, Ma p& dar buon principio al nostro insegnare a scriuere, nui principiaremo da quelle che sono piu bisognose & necessarie uniuersalmẽte a ognuno cioe quelle che piu se costumano al presente in diuerse cancellarie, & maxime in quella del serenissimo dominio Venetiano dal quale gia molti anni fui & sono prouisionato per merito di questa uirtute, & cosi a queste qualita de lettere cancellaresche daremo bono principio e prima.

Conciosia cosa discreto lettore che allo amaestramẽto de insegnare a scriuere le soprascrite qualita de lettere io te poteria dire (& tu douesti imparare prima gli alphabeti et poi gli uersi, con la uirtu della tua prudentia, praticando et retrahendo gli mei essempli in breui giorni ti potresti fare eccellente scrittore, de quelle qualita de lettere cancellare-

te si come qui di sotto tu uedi lo esempio.

o o o

A Dunque a questa altra consideratione sapi che questo soprascritto corpo fatto con la sua misura et arte, presto presto adoperando col tuo ingegno per arte de la geometria trazerai queste sottoscritte tre lettere, le quale te scriuo qui di sotto per tuo esempio.

o oo adg ooo adg

La sopradetta lettera, a, se trazze del soprascritto corpo in questo modo, prima tirerai una gamba ritta che sia uno poco pendente a canto del ditto corpo in tal modo che la maggior parte del ditto corpo rimanga serrato, & in ultimo della predetta gamba daragli uno poco di garbetto, ilquale garbetto si chiama una lassata perche la lassi, perche il suo finimento si come qui di sotto tu uedi lo esempio, per tuo amaestramento.

aa aa aa

A lettera, b, si trazze pur del quadro, & si tira prima una asta uiua & galiarda laquale habbia uno poco di dependentia, si come festi alla lettera, a, con uno punto fermo & pẽdente, nel suo principio in forma de uno punto nel princi

sche, ouer de altra qualita che uorrai imparare, ma per maggiore tua dilucidationi & accio che con maggiore prestezza di tempo, tu possi imparare io qui seguente ti daro la ragioue con li secreti & maestreuoli modi, a lettera per lettera, et poi anchora ti daro la ragione della legatura, & incatenatura, di tutti gli nomi, con larte di la geometria,

Considerando adongue in questo nostro primo amaestramento, sapi come tutte le lettere dello alphabeto cãcellarescho enseno da questo sottoscritto quadro bislongo come seguendo piu chiaramente intenderai.

:: :: :: :: ::

& per dartilo secondo amaestramẽto sapi che uolendo imparare la predetta lettera cancellarescha, prima el te bisogna imparare tutte le lettere dello alphabeto su le rige, & poi quando saperai scriuere, scriuerai senza riga per fino (& la mano hauera compresa la sua perfettione, lequale letterie dello alphabeto imparerai a fare prima questo sottoscritto corpo ilquale ense del quadro bislongo, et penden

pio de lasta & poi quando serai in capo de lasta a canto la riga ritornerai in su per la medesima hassa in tal modo che tu possi fabricare il corpo della lettera a, alla rouersa & sara fabricata la tua lettera, b, ma fagli romagnire lo suo corpo, uno poco aperto si come festi alla lettera, a, come tu uedi lo sottoscritto exempio.

b b b b

La lettera c, si trazze del quadro bislongo si come festi nel corpo della lettera a, ma ben el si tira in doi tratti e prima tu hai a tirar uno mezo corpo della lettera a, et poi tu haverai a pigliare la ultima extremita di sopra del ditto mezo corpo, & farai uno ponto che uengi tondizãdo, allo camino come se tu uolesti chiudere per fare la lettera o, in doi tratti si come tu uedi lo sottoscritto exempio.

cc ccc ccc a

La lettera d, farai come festi la lettera a, & cõ lasta della lettera b, come tu uedi lo sottoscritto exempio.

dd dd dd

La lettera e, la farai si come tu festi la lettera c, a pũto eccetto quando tirarai lo punto di sopra della lettera c, intrarai

SAppi lettor dignißimo, che le lettere cancellaresche fono de diuerfe qualita di corpi, aste, legature, & incatenature, torture, dritte tonde & nõ tonde, trattizate & fenza tratti, & altri fentimēti de altre nature come hai potuto uedere nelle fcritte qualita de lettere, lequali fi ufano nelle cancellarie de tutte le cita della Italia, & doue fi coffuma una qualita, e doue una tra, Ma pẽ dar buon principio al noftro infegnare a fcriuere, nui principiaremo da quelle che fono piu bifognofe & neceßarie uniuerfalmēte a ognuno cioe quelle che piu fe coftumano al prefente in diuerfe cancellarie, &t maxime in quella del ferenißimo dominio Venetiano dal quale gia molti anni fui & fono prouifionato per merito di quefta uirtute, & cofi a quefte qualita de lettere cancellarefche daremo bono principio e prima.

Concifia cofa difcreto lettore che allo amaeftramēto de infegnare a fcriuere le foprafcrite qualita de lettere io te poteria dire (&t u doueft imparare prima gli alphabeti et poi gli uerfi, con la uirtu della tua prudentia, praticando et retrahendo gli mei efempli in breui giorni ti potreft fare eccellente fcrittore, de quelle qualita de lettere cancellare-

te fi come qui di fotto tu uedi lo efempio.

ADungue a quefta altra confideratione fapi che quefto foprafcritto corpo fatto con la fua mifura et arte, prefto prefto adoperando col tuo ingegno per arte de la geometria trazerai quefte fottofcritte tre lettere, lequale te fcriuo qui di fotto per tuo efempio.

adg adg

La fopradetta lettera a, fe trazze del foprafcritto corpo in quefto modo, prima tirerai una gamba ritta che fia uno poco pendente a canto del ditto corpo in tal modo c he la maggior parte del ditto corpo rimanga ferrato, &t in ultimo della preditta gamba daragli uno poco di garbetto, ilquale garbetto fi chiama una laßata perche la laßi, per che il fuo finimento fi come qui di fotto tu uedi lo efempio, per tuo amaeftramento.

aa aa aa

A lettera, b, fi trazze pur del quadro, &t fi tira prima una afta uiua & galiarda laquale habbia uno poco di dependentia, fi come fefti alla lettera a, con uno punto fermo & pēdente, nel fuo principio in forma de uno punto nel princi-

fche, ouer de altra qualita che uorrai imparare, ma per maggiore tua dilucidationi & accio che con maggiore preftezza di tempo, tu poßi imparare io qui feguente ti daro la ragioue con li fecreti & maeftreuoli modi, a lettera per lettera, et poi anchora ti daro la ragione della legatura, & incatenatura, di tutti gli nomi, con larte di la geometria,

Onfiderando adongue in quefto noftro primo amaeftramento, fapi come tutte le lettere dello alphabeto cãcellarefcho enfeno da quefto fottofcritto quadro bislongo come feguendo piu chiaramente intenderai.

:: :: :: :: ::

&t per darti lo fecondo amaeftramēto fapi che uolendo imparare la preditta lettera cancellarefcha, prima el te bifogna imparare tutte le lettere dello alphabeto fu le rige, & poi quando faperai fcriuere, fcriuerai fenza riga per fino (&t la mano hauera comprefa la fua perfettione, lequale lettere dello alphabeto impararai a fare prima quefto fottofcritto corpo ilquale enfe del quadro bislongo, et penden-

pio de lafta & poi quando ferai in capo de lafta a canto la riga ritornerai in fu per la medefima haffa in tal modo che tu poßi fabricare il corpo della lettera a, alla rouerfa & fara fabricata la tua lettera, b, ma fagli romagnire lo fuo corpo, uno poco aperto fi come fefti alla lettera, a, come tu uedi lo fottofcritto exempio.

b b b b

La lettera c, fi trazze del quadro bislongo fi come fefti nel corpo della lettera a, ma ben el fi tira in doi tratti e prima tu hai a tirar uno mezo corpo della lettera a, et poi tu hauerai a pigliare la ultima extremita di fopra del ditto mezo corpo, & farai uno ponto che uengi tondizãdo, allo camino come fe tu uolefti chiudere per fare la lettera o, in doi tratti fi come tu uedi lo fottofcritto exempio.

cc ccc ccc

La lettera d, farai come fefti la lettera a, & cõ lafta della lettera b, come tu uedi lo fottofcritto exempio.

dd dd dd

La lettera e, la farai fi come tu fefti la lettera c, a pũto eccetto quando tirarai lo punto di fopra della lettera c, intrarai

15

When I consider euery thing that growes
Holds in perfection but a little moment.
That this huge stage presenteth nought but showes
Whereon the Stars in secret influence comment.
When I perceiue that men as plants increase,
Cheared and checkt euen by the selfe-same skie:
Vaunt in their youthfull sap, at height decrease,
And were their braue state out of memory.
Then the conceit of this inconstant stay,
Sets you most rich in youth before my sight,
Where wastfull time debateth with decay
To change your day of youth to sullied night,
 And all in war with Time for loue of you
 As he takes from you, I ingraft you new.

130

My Mistres eyes are nothing like the Sunne,
Currall is farre more red, then her lips red,
If snow be white, why then her brests are dun:
If haires be wiers, black wiers grow on her head:
I haue seene Roses damaskt, red and white,
But no such Roses see I in her cheekes,
And in some perfumes is there more delight,
Then in the breath that from my Mistres reekes.
I loue to heare her speake, yet well I know,
That Musicke hath a farre more pleasing sound:
I graunt I neuer saw a goddesse goe,
My Mistres when shee walkes treads on the ground.
 And yet by heauen I thinke my loue as rare,
 As any she beli'd with false compare.

138

When my loue sweares that she is made of truth,
I do beleeue her though I know she lyes,
That she might thinke me some vnvtterd youth,
Vnlearned in the worlds false subtilties.
Thus vainely thinking that she thinkes me young,
Although she knowes my dayes are past the best,
Simply I credit her false speaking tongue,
On both sides thus is simple truth supprest :
But wherefore sayes she not she is vniust ?
And wherefore say not I that I am old ?
O loues best habit is in seeming trust,
And age in loue, loues not t'haue yeares told.
 Therefore I lye with her, and she with me,
 And in our faults by lyes we flattered be.

18.

Shall I compare thee to a Summers day?
Thou art more louely and more temperate:
Rough windes do shake the darling buds of Maie,
And Sommers lease hath all too short a date:
Sometime too hot the eye of heauen shines,
And often is his gold complexion dimm'd,
And euery faire from faire some-time declines,
By chance, or natures changing course vntrim'd:
But thy eternall Sommer shall not fade,
Nor loose possession of that faire thou ow'st,
Nor shall death brag thou wandr'st in his shade,
When in eternall lines to time thou grow'st,
 So long as men can breath or eyes can see,
 So long liues this, and this giues life to thee,

18.

Shall I compare thee to a Summers day?
Thou art more louely and more temperate:
Rough windes do shake the darling buds of Maie,
And Sommers lease hath all too short a date:
Sometime too hot the eye of heauen shines,
And often is his gold complexion dimm'd,
And euery faire from faire some-time declines,
By chance, or natures changing course vntrim'd:
But thy eternall Sommer shall not fade,
Nor loose possession of that faire thou ow'st,
Nor shall death brag thou wandr'st in his shade,
When in eternall lines to time thou grow'st,
 So long as men can breath or eyes can see,
 So long liues this, and this giues life to thee,

15

When I consider euery thing that growes
Holds in perfection but a little moment.
That this huge stage presenteth nought but showes
Whereon the Stars in secret influence comment.
When I perceiue that men as plants increase,
Cheared and checkt euen by the selfe-same skie:
Vaunt in their youthfull sap, at height decrease,
And were their braue state out of memory.
Then the conceit of this inconstant stay,
Sets you most rich in youth before my sight,
Where wastfull time debateth with decay
To change your day of youth to sullied night,
 And all in war with Time for loue of you
 As he takes from you, I ingraft you new.

130

My Mistres eyes are nothing like the Sunne,
Currall is farre more red, then her lips red,
If snow be white, why then her brests are dun:
If haires be wiers, black wiers grow on her head:
I haue seene Roses damaskt, red and white,
But no such Roses see I in her cheekes,
And in some perfumes is there more delight,
Then in the breath that from my Mistres reekes.
I loue to heare her speake, yet well I know,
That Musicke hath a farre more pleasing sound:
I graunt I neuer saw a goddesse goe,
My Mistres when shee walkes treads on the ground.
 And yet by heauen I thinke my loue as rare,
 As any she beli'd with false compare.

138

When my loue sweares that she is made of truth,
I do beleeue her though I know she lyes,
That she might thinke me some vnvtterd youth,
Vnlearned in the worlds false subtilties.
Thus vainely thinking that she thinkes me young,
Although she knowes my dayes are past the best,
Simply I credit her false speaking tongue,
On both sides thus is simple truth supprest :
But wherefore sayes she not she is vniust ?
And wherefore say not I that I am old ?
O loues best habit is in seeming trust,
And age in loue, loues not t'haue yeares told.
 Therefore I lye with her, and she with me,
 And in our faults by lyes we flattered be.

138

When my loue sweares that she is made of truth,
I do beleeue her though I know she lyes,
That she might thinke me some vnvtterd youth,
Vnlearned in the worlds false subtilties.
Thus vainely thinking that she thinkes me young,
Although she knowes my dayes are past the best,
Simply I credit her false speaking tongue,
On both sides thus is simple truth supprest :
But wherefore sayes she not she is vniust ?
And wherefore say not I that I am old ?
O loues best habit is in seeming trust,
And age in loue, loues not t'haue yeares told.
 Therefore I lye with her, and she with me,
 And in our faults by lyes we flattered be.

18.

Shall I compare thee to a Summers day?
Thou art more louely and more temperate:
Rough windes do shake the darling buds of Maie,
And Sommers lease hath all too short a date:
Sometime too hot the eye of heauen shines,
And often is his gold complexion dimm'd,
And euery faire from faire some-time declines,
By chance, or natures changing course vntrim'd:
But thy eternall Sommer shall not fade,
Nor loose possession of that faire thou ow'st,
Nor shall death brag thou wandr'st in his shade,
When in eternall lines to time thou grow'st,
 So long as men can breath or eyes can see,
 So long liues this, and this giues life to thee,

15

When I consider euery thing that growes
Holds in perfection but a little moment.
That this huge stage presenteth nought but showe
Whereon the Stars in secret influence comment.
When I perceiue that men as plants increase,
Cheared and checkt euen by the selfe-same skie:
Vaunt in their youthfull sap, at height decrease,
And were their braue state out of memory.
Then the conceit of this inconstant stay,
Sets you most rich in youth before my sight,
Where wastfull time debateth with decay
To change your day of youth to sullied night,
 And all in war with Time for loue of you
 As he takes from you, I ingraft you new.

130

My Mistres eyes are nothing like the Sunne,
Currall is farre more red, then her lips red,
If snow be white, why then her brests are dun:
If haires be wiers, black wiers grow on her head:
I haue seene Roses damaskt, red and white,
But no such Roses see I in her cheekes,
And in some perfumes is there more delight,
Then in the breath that from my Mistres reekes.
I loue to heare her speake, yet well I know,
That Musicke hath a farre more pleasing sound:
I graunt I neuer saw a goddesse goe,
My Mistres when shee walkes treads on the ground.
 And yet by heauen I thinke my loue as rare,
 As any she beli'd with false compare.

15

When I confider euery thing that growes
Holds in perfection but a little moment.
That this huge ftage prefenteth nought but fhowes
Whereon the Stars in fecret influence comment.
When I perceiue that men as plants increafe,
Cheared and checkt euen by the felfe-fame skie:
Vaunt in their youthfull fap, at height decreafe,
And were their braue ftate out of memory.
Then the conceit of this inconftant ftay,
Sets you moft rich in youth before my fight,
Where waftfull time debateth with decay
To change your day of youth to fullied night,
 And all in war with Time for loue of you
 As he takes from you, I ingraft you new.

130

My Miftres eyes are nothing like the Sunne,
Currall is farre more red, then her lips red,
If fnow be white, why then her brefts are dun:
If haires be wiers, black wiers grow on her head:
I haue feene Rofes damaskt, red and white,
But no fuch Rofes fee I in her cheekes,
And in fome perfumes is there more delight,
Then in the breath that from my Miftres reekes.
I loue to heare her fpeake, yet well I know,
That Muficke hath a farre more pleafing found:
I graunt I neuer faw a goddeffe goe,
My Miftres when fhee walkes treads on the ground.
 And yet by heauen I thinke my loue as rare,
 As any fhe beli'd with falfe compare.

138

When my loue fweares that fhe is made of truth,
 I do beleeue her though I know fhe lyes,
That fhe might thinke me fome vntuterd youth,
Vnlearned in the worlds falfe fubtilties.
Thus vainely thinking that fhe thinkes me young,
Although fhe knowes my dayes are paft the beft,
Simply I credit her falfe fpeaking tongue,
On both fides thus is fimple truth fuppreft:
But wherefore fayes fhe not fhe is vniuft?
And wherefore fay not I that I am old?
O loues beft habit is in feeming truft,
And age in loue, loues not t'haue yeares told.
 Therefore I lye with her, and fhe with me,
 And in our faults by lyes we flattered be.

18.

Shall I compare thee to a Summers day?
Thou art more louely and more temperate:
Rough windes do fhake the darling buds of Maie,
And Sommers leafe hath all too fhort a date:
Sometime too hot the eye of heauen fhines,
And often is his gold complexion dimm'd,
And euery faire from faire fome-time declines,
By chance, or natures changing courfe vntrim'd:
But thy eternall Sommer fhall not fade,
Nor loofe poffeffion of that faire thou ow'ft,
Nor fhall death brag thou wandr'ft in his fhade,
When in eternall lines to time thou grow'ft,
 So long as men can breath or eyes can fee,
 So long liues this, and this giues life to thee,

18.

Shall I compare thee to a Summers day?
Thou art more louely and more temperate:
Rough windes do fhake the darling buds of Maie,
And Sommers leafe hath all too fhort a date:
Sometime too hot the eye of heauen fhines,
And often is his gold complexion dimm'd,
And euery faire from faire fome-time declines,
By chance, or natures changing courfe vntrim'd:
But thy eternall Sommer fhall not fade,
Nor loofe poffeffion of that faire thou ow'ft,
Nor fhall death brag thou wandr'ft in his fhade,
When in eternall lines to time thou grow'ft,
 So long as men can breath or eyes can fee,
 So long liues this, and this giues life to thee,

15

When I confider euery thing that growes
 Holds in perfection but a little moment.
That this huge ftage prefenteth nought but fhowes
Whereon the Stars in fecret influence comment.
When I perceiue that men as plants increafe,
Cheared and checkt euen by the felfe-fame skie:
Vaunt in their youthfull fap, at height decreafe,
And were their braue ftate out of memory.
Then the conceit of this inconftant ftay,
Sets you moft rich in youth before my fight,
Where waftfull time debateth with decay
To change your day of youth to fullied night,
 And all in war with Time for loue of you
 As he takes from you, I ingraft you new.

130

My Miftres eyes are nothing like the Sunne,
Currall is farre more red, then her lips red,
If fnow be white, why then her brefts are dun:
If haires be wiers, black wiers grow on her head:
I haue feene Rofes damaskt, red and white,
But no fuch Rofes fee I in her cheekes,
And in fome perfumes is there more delight,
Then in the breath that from my Miftres reekes.
I loue to heare her fpeake, yet well I know,
That Muficke hath a farre more pleafing found:
I graunt I neuer faw a goddeffe goe,
My Miftres when fhee walkes treads on the ground.
 And yet by heauen I thinke my loue as rare,
 As any fhe beli'd with falfe compare.

138

When my loue fweares that fhe is made of truth,
 I do beleeue her though I know fhe lyes,
That fhe might thinke me fome vntuterd youth,
Vnlearned in the worlds falfe fubtilties.
Thus vainely thinking that fhe thinkes me young,
Although fhe knowes my dayes are paft the beft,
Simply I credit her falfe fpeaking tongue,
On both fides thus is fimple truth fuppreft:
But wherefore fayes fhe not fhe is vniuft?
And wherefore fay not I that I am old?
O loues beft habit is in feeming truft,
And age in loue, loues not t'haue yeares told.
 Therefore I lye with her, and fhe with me,
 And in our faults by lyes we flattered be.

138

When my loue fweares that fhe is made of truth,
 I do beleeue her though I know fhe lyes,
That fhe might thinke me fome vntuterd youth,
Vnlearned in the worlds falfe fubtilties.
Thus vainely thinking that fhe thinkes me young,
Although fhe knowes my dayes are paft the beft,
Simply I credit her falfe fpeaking tongue,
On both fides thus is fimple truth fuppreft:
But wherefore fayes fhe not fhe is vniuft?
And wherefore fay not I that I am old?
O loues beft habit is in feeming truft,
And age in loue, loues not t'haue yeares told.
 Therefore I lye with her, and fhe with me,
 And in our faults by lyes we flattered be.

18.

Shall I compare thee to a Summers day?
Thou art more louely and more temperate:
Rough windes do fhake the darling buds of Maie,
And Sommers leafe hath all too fhort a date:
Sometime too hot the eye of heauen fhines,
And often is his gold complexion dimm'd,
And euery faire from faire fome-time declines,
By chance, or natures changing courfe vntrim'd:
But thy eternall Sommer fhall not fade,
Nor loofe poffeffion of that faire thou ow'ft,
Nor fhall death brag thou wandr'ft in his fhade,
When in eternall lines to time thou grow'ft,
 So long as men can breath or eyes can fee,
 So long liues this, and this giues life to thee,

15

When I confider euery thing that growes
 Holds in perfection but a little moment.
That this huge ftage prefenteth nought but fhowes
Whereon the Stars in fecret influence comment.
When I perceiue that men as plants increafe,
Cheared and checkt euen by the felfe-fame skie:
Vaunt in their youthfull fap, at height decreafe,
And were their braue ftate out of memory.
Then the conceit of this inconftant ftay,
Sets you moft rich in youth before my fight,
Where waftfull time debateth with decay
To change your day of youth to fullied night,
 And all in war with Time for loue of you
 As he takes from you, I ingraft you new.

130

My Miftres eyes are nothing like the Sunne,
Currall is farre more red, then her lips red,
If fnow be white, why then her brefts are dun:
If haires be wiers, black wiers grow on her head:
I haue feene Rofes damaskt, red and white,
But no fuch Rofes fee I in her cheekes,
And in fome perfumes is there more delight,
Then in the breath that from my Miftres reekes.
I loue to heare her fpeake, yet well I know,
That Muficke hath a farre more pleafing found:
I graunt I neuer faw a goddeffe goe,
My Miftres when fhee walkes treads on the ground.
 And yet by heauen I thinke my loue as rare,
 As any fhe beli'd with falfe compare.

Le' lettere' cancellaresche' sopranominate' se' fanno tonde'
longe' large' tratizzate' e' non tratizzate ET per che' io
to scritto questa' uariacione' de lettera' la qual im=
pareraj secundo li nostri precetti et opera

A ala b.c.d.e.f.g.h.i.k.l.m.n.o.p.q.r.s.t.u.x.y.z.&

Le' lettere' cancellaresche' sopranominate' se' fanno tonde'
longe' large' tratizzate' e' non tratizzate ET per che' io
to scritto questa' uariacione' de lettera' la qual im=
pareraj secundo li nostri precetti et opera

A ala b.c.d.e.f.g.h.i.k.l.m.n.o.p.q.r.s.t.u.x.y.z.&

Le' lettere' cancellaresche' sopranominate' se' fanno tonde'
longe' large' tratizzate' e' non tratizzate ET per che' io
to scritto questa' uariacione' de lettera' la qual im=
pareraj secundo li nostri precetti et opera

A ala b.c.d.e.f.g.h.i.k.l.m.n.o.p.q.r.s.t.u.x.y.z.&

Le' lettere' cancellaresche' sopranominate' se' fanno tonde'
longe' large' tratizzate' e' non tratizzate ET per che' io
to scritto questa' uariacione' de lettera' la qual im=
pareraj secundo li nostri precetti et opera

A ala b.c.d.e.f.g.h.i.k.l.m.n.o.p.q.r.s.t.u.x.y.z.&

Le' lettere' cancellaresche' sopranominate' se' fanno tonde'
longe' large' tratizzate' e' non tratizzate ET per che' io
to scritto questa' uariacione' de lettera' la qual im=
pareraj secundo li nostri precetti et opera

A ala b.c.d.e.f.g.h.i.k.l.m.n.o.p.q.r.s.t.u.x.y.z.&

Le' lettere' cancellaresche' sopranominate' se' fanno tonde'
longe' large' tratizzate' e' non tratizzate ET per che' io
to scritto questa' uariacione' de lettera' la qual im=
pareraj secundo li nostri precetti et opera

A ala b.c.d.e.f.g.h.i.k.l.m.n.o.p.q.r.s.t.u.x.y.z.&

Le' lettere' cancellaresche' sopranominate' se' fanno tonde'
longe' large' tratizzate' e' non tratizzate ET per che' io
to scritto questa' uariacione' de lettera' la qual im=
pareraj secundo li nostri precetti et opera

A ala b.c.d.e.f.g.h.i.k.l.m.n.o.p.q.r.s.t.u.x.y.z.&

Le lettere cancellaresche sopranominate se fanno tonde
longe large tratizzate e non tratizate ET per che io
to scritto questa uariacione de lettera la qual im=
pareraj secundo li nostri precetti et opera

A a/a b.c.d.e.f.g.h.i.k.l.m.n.o.p.q.r.s.f.t.u.x.y.z.&.

Le lettere cancellaresche sopranominate se fanno tonde
longe large tratizzate e non tratizate ET per che io
to scritto questa uariacione de lettera la qual im=
pareraj secundo li nostri precetti et opera

A a/a b.c.d.e.f.g.h.i.k.l.m.n.o.p.q.r.s.f.t.u.x.y.z.&.

Le lettere cancellaresche sopranominate se fanno tonde
longe large tratizzate e non tratizate ET per che io
to scritto questa uariacione de lettera la qual im=
pareraj secundo li nostri precetti et opera

A a/a b.c.d.e.f.g.h.i.k.l.m.n.o.p.q.r.s.f.t.u.x.y.z.&.

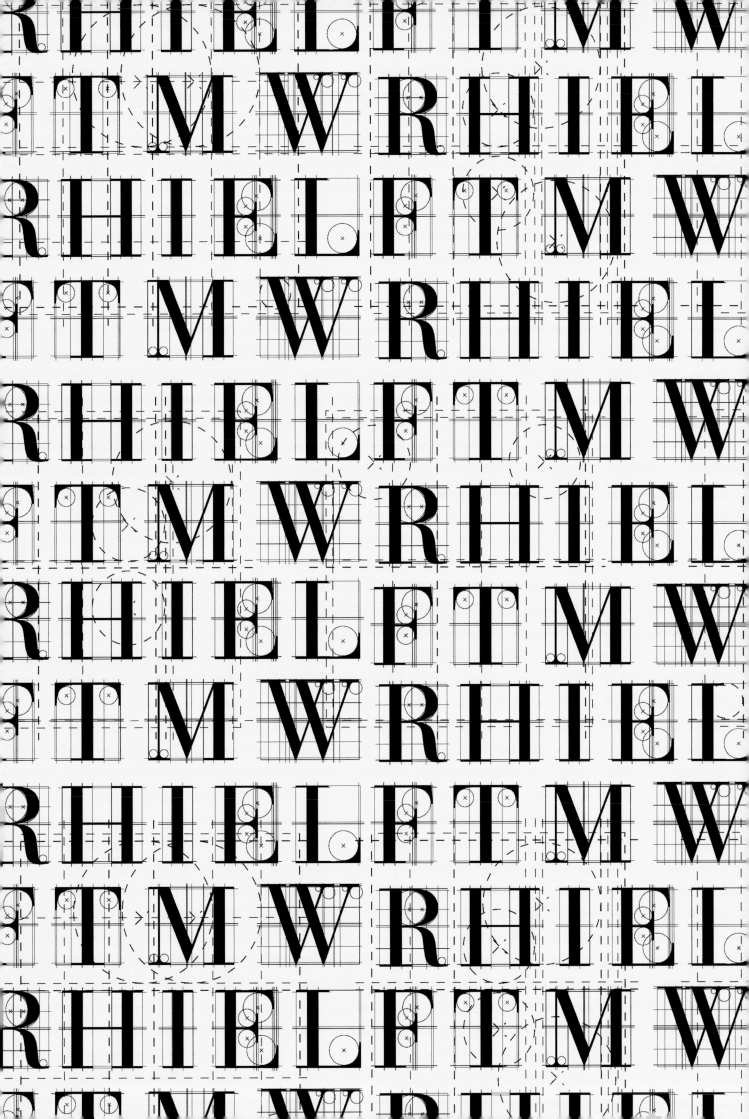

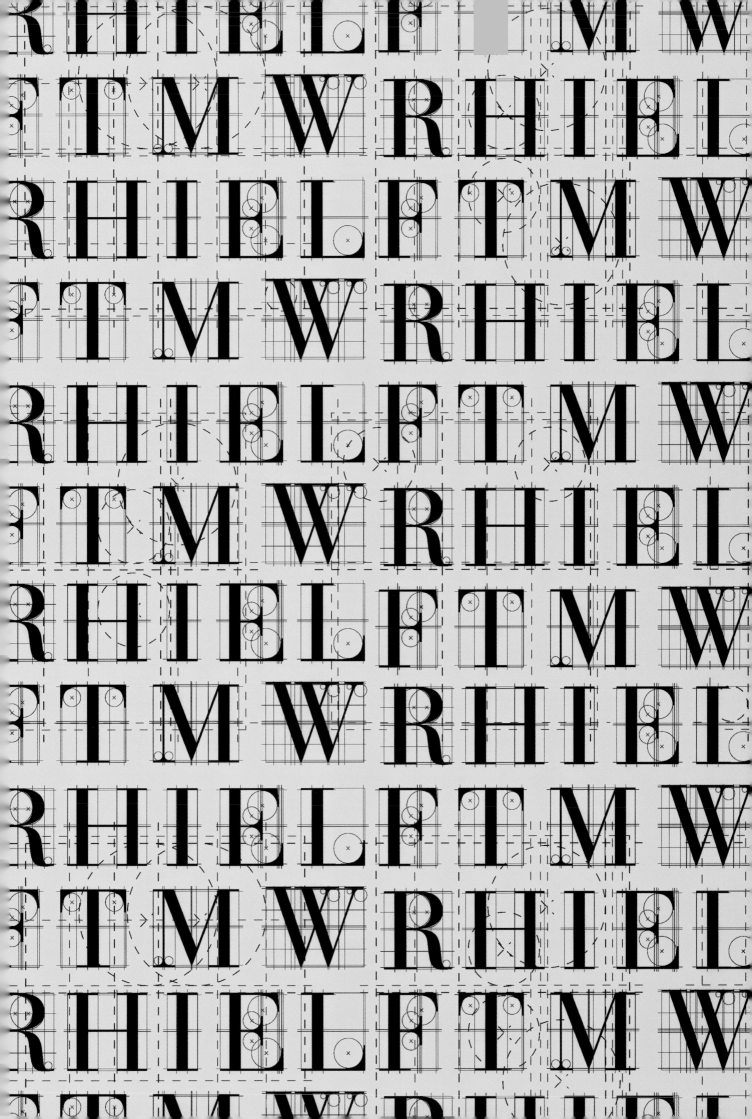

and Conveniences therewith connected, to be called the "Edinburgh & Bathgate
ce at a point on the Edinburgh and Glasgow Railway, at or near to the Rath
Parish of Ratho, and County of Edinburgh; or in that part of the Parish of Ki
said County of Edinburgh, or one or other of them, and to terminate within, at, or
rgh of Bathgate, in the Parish of Bathgate, and County of Linlithgow, by a jun
dee Railway from Airdrie to Bathgate, or otherways; Together also with
ways, with all proper Works and Conveniences therewith connected, viz: First, A Bra
m the said intended Main Line of Railway, at or near to the Lands or Farm
of the Parish of Kirkliston situated within the County of Edinburgh, or at or n
of Elliston or Illiston, situated in the Parish of Uphall, and County of Li
l of the Parish of Kirkliston situated within the said County of Linlithgow,
r to the Town or Village of Mid Calder, in the Parish of Mid Calder, & Coun
point betwixt the Towns or Villages of Mid Calder and East Calder, in the t
d Parishes of Kirknewton and East Calder, in the County of Edinburgh; Secon
diverge from the said intended Main Line of Railway, at or near to the Fa
d Parish of Uphall and County of Linlithgow, to the Freestone Quarries of B
the said Parish of Linlithgow, and partly within the said Parish of Up
ty of Linlithgow; Third, A Branch Railway to diverge from the said intended Ma
a point at or near to the Lands or Farm of Barracks, in the Parish of Livingst
gow aforesaid, or from a point at or near to the Farm of Tailend, in the Par
Farm of Deans, in the said Parish of Bathgate, and County of Linlithgow, and
at, in, or near to the Village of Whitburn, in the Parish of Whitburn, & Coun
d: Fourth, A Branch Railway from or near to the point at which the said in
Railway will terminate at Bathgate aforesaid, to, or near to the point at which
way to Whitburn will terminate at Whitburn aforesaid; with a connecting Lin
ed Branch Line to the Village of Blackburn, in the Parish of Livingstone afo
ther Connecting Line from said Branch Railway to Whitburn, from a point at
loss-side, to another point on the said intended Main Line, at or near to the La
g Grove, all in the Parish of Bathgate, and County of Linlithgow aforesaid; a
l, or some of them, all as shewn on the Plan aftermentioned, or some parts or portio
Railways and Branches, and that the Property mentioned in the annexed Sche
which I understand you are interested, as therein stated, will be required for t
Undertaking according to the lines thereof, as at present laid out, or may be requi
usual powers of deviation, to the usual extent of One Hundred Yards on either si
te extent of the limit of deviation delineated on the plans aftermentioned; which
the said Act, and will be passed through, in the manner mentioned in such Sched
also beg to inform you, that a Plan and Section of the said Undertaking, with a Book
eposited in the Office in Edinburgh of the principal Sheriff Clerk of the Coun by
fice in Linlithgow of the principal Sheriff Clerk of the County of Linlithgow, on the
nd that Copies of the said Plan and Section, with a Book of Reference thereto, will
nection with the Schoolmaster, if any, and if there be no Schoolmaster, with the Sessio
which your Property is situate, and with the Town Clerk of the Town or Burgh of Ba
day of December instant, on which Plans your Property is designated by the numbers s
hedule. As I am required to report to Parliament, whether you assent to or dissen
taking, or whether you are neuter in respect thereto, you will oblige me by writ
t dissent, or neutrality, in the form left herewith, and returning the same to me, wit
ore the 8th day of January next, and if there should be any error or misdescription
I shall feel obliged by your informing me thereof, at your earliest convenience, that

and Conveniences therewith connected, to be called the "Edinburgh & Bathga[te]
...ce at a point on the Edinburgh and Glasgow Railway, at or near to the Rail[way]
...Parish of Ratho, and County of Edinburgh, or in that part of the Parish of K[irkliston]
...said County of Edinburgh, or one or other of them, and to terminate, within, at, or [near]
...gh of Bathgate, in the Parish of Bathgate, and County of Linlithgow, by a ju[nction]
...tended Railway from Airdrie to Bathgate, or otherways: Together also with...
...ways, with all proper Works and Conveniences therewith connected, viz. First, A Br[anch]
...m the said intended Main Line of Railway, at or near to the Lands or Farm...
...of the Parish of Kirkliston situated within the County of Edinburgh, or at or...
...of Elliston or Illiston, situated in the Parish of Uphall, and County of L[inlithgow]
...t of the Parish of Kirkliston situated within the said County of Linlithgow...
...r to the Town or Village of Mid Calder, in the Parish of Mid Calder, & Coun[ty]
...point betwixt the Towns or Villages of Mid Calder and East Calder, in the...
...ed Parishes of Kirknewton and East Calder, in the County of Edinburgh, Seco[nd]
...to diverge from the said intended Main Line of Railway, at or near to the Fa[rm]
...d Parish of Uphall and County of Linlithgow, to the Freestone Quarries of...
...the said Parish of Linlithgow, and partly within the said Parish of U[phall]
...ty of Linlithgow, Third, A Branch Railway to diverge from the said intended M[ain]
...a point at or near to the Lands or Farm of Barracks, in the Parish of Livings[tone]
...hgow aforesaid, or from a point at or near to the Farm of Tailend, in the Par[ish]
...Farm of Deans, in the said Parish of Bathgate, and County of Linlithgow, and...
...at, in, or near to the Village of Whitburn, in the Parish of Whitburn, & Coun[ty]
...d: Fourth, A Branch Railway from or near to the point at which the said...
...Railway will terminate at Bathgate aforesaid, to, or near to the point at whic[h]
...way to Whitburn will terminate at Whitburn aforesaid, with a connecting Lin[e]
...ned Branch Line to the Village of Blackburn, in the Parish of Livingstone af...
...her Connecting Line from said Branch Railway to Whitburn, from a point at...
...loss-side, to another point on the said intended Main Line, at or near to the La[nds]
...g Grove, all in the Parish of Bathgate, and County of Linlithgow aforesaid,...
...d, or some of them, all as shewn on the Plan aftermentioned, or some part or porti[on]
...Railways and Branches, and that the Property mentioned in the annexed Sche[dule]
...which I understand you are interested, as therein stated, will be required for...
...Undertaking according to the lines thereof, as at present laid out, or may be requi[red]
...usual powers of deviation, to the usual extent of One Hundred Yards on either su[rface]
...he extent of the limit of deviation delineated on the plans aftermentioned; which...
...the said Act, and will be passed through, in the manner mentioned in such Sched[ule]
...also beg to inform you, that a Plan and Section of the said Undertaking, with a Book...
...deposited in the Office in Edinburgh of the principal Sheriff Clerk of the Coun[ty]
...fice in Linlithgow of the principal Sheriff Clerk of the County of Linlithgow on the...
...nd that Copies of the said Plan and Section, with a Book of Reference thereto, will...
...Section, with the Schoolmaster, if any, and if there be no Schoolmaster, with the Sessi[on]
...which your Property is situate, and with the Town Clerk of the Town or Burgh of Ba[thgate]
...day of December instant, on which Plans your Property is designated by the number...
...dule. As I am required to report to Parliament, whether you assent to or dissen[t]
...taking, or whether you are neuter in respect thereto, you will oblige me by writ[ing]
...f dissent, or neutrality, in the form left herewith, and returning the same to me, wi[th]
...re the 8th day of January next, and if there should be any error or misdescripti[on]
...I shall feel obliged by your informing me thereof at your earliest conven[ience]

and Conveniences therewith connected, to be called the "Edinburgh & Bathgate ... at a point on the Edinburgh and Glasgow Railway, at or near to the Rath... Parish of Ratho, and County of Edinburgh, or in that part of the Parish of Ki... said County of Edinburgh, or one or other of them, and to terminate, within, at, orgh of Bathgate, in the Parish of Bathgate, and County of Linlithgow, by a jun... ...ded Railway from Airdrie to Bathgate, or otherways, Together also withways, with all proper Works and Conveniences therewith connected, viz: First. A Bra... ...n the said intended Main Line of Railway, at or near to the Lands or Farmof the Parish of Kirkliston situated within the County of Edinburgh, or at or n... ...of Elliston or Illiston, situated in the Parish of Uphall, and County of Li... ...l of the Parish of Kirkliston situated within the said County of Linlithgow,r to the Town or Village of Mid Calder, in the Parish of Mid Calder, & Coun... ...point betwixt the Towns or Villages of Mid Calder and East Calder, in thed Parishes of Kirknewton and East Calder, in the County of Edinburgh; Secon... ...diverge from the said intended Main Line of Railway, at or near to the Fa... ...d Parish of Uphall and County of Linlithgow, to the Freestone Quarries of B... ...the said Parish of Linlithgow, and partly within the said Parish of Up... ...ty of Linlithgow; Third. A Branch Railway to diverge from the said intended M... ...a point at or near to the Lands or Farm of Barracks, in the Parish of Livings... ...gow aforesaid, or from a point at or near to the Farm of Tailend, in the Par... ...Farm of Deans, in the said Parish of Bathgate, and County of Linlithgow, andat, in, or near to the Village of Whitburn, in the Parish of Whitburn, & Coun... ...l: Fourth. A Branch Railway from or near to the point at which the said in... ...Railway will terminate at Bathgate aforesaid, to, or near to the point at whichway to Whitburn will terminate at Whitburn aforesaid, with a connecting Lin... ...ned Branch Line to the Village of Blackburn, in the Parish of Livingstone af... ...her Connecting Line from said Branch Railway to Whitburn, from a point atloss-side, to another point on the said intended Main Line, at or near to the La... ...g Grove, all in the Parish of Bathgate, and County of Linlithgow aforesaid,d, or some of them, all as shewn on the Plan aftermentioned, or some parts or portio... ...Railways and Branches, and that the Property mentioned in the annexed Sche... ...which I understand you are interested, as therein stated, will be required for t... ...Undertaking according to the lines thereof, as at present laid out, or may be requi... ...usual powers of deviation, to the usual extent of One Hundred Yards on either si... ...he extent of the limit of deviation delineated on the plans aftermentioned, whichthe said Act, and will be passed through, in the manner mentioned in such Sched... ...also beg to inform you, that a Plan and Section of the said Undertaking, with a Bookeposited in the Office in Edinburgh of the principal Sheriff Clerk of the Coun... ...fice in Linlithgow of the principal Sheriff Clerk of the County of Linlithgow, on thend that Copies of the said plan and Section, with a Book of Reference thereto, willnection with the Schoolmaster, if any, and if there be no Schoolmaster, with the Sessi... ...hich your Property is situate, and with the Town Clerk of the Town or Burgh of Bo... ...day of December instant, on which Plans your Property is designated by the numbers inedule. As I am required to report to Parliament, whether you assent to or dissen... ...taking, or whether you are neuter in respect thereto, you will oblige me by writ... ...d dissent, or neutrality, in the form left herewith, and returning the same to me, withore the 8th day of January next, and if there should be any error or misdescriptionI shall feel obliged by your informing me thereof at your earliest convenience, that ...

and Conveniences therewith connected, to be called the "Edinburgh & Bathgate
...ce at a point on the Edinburgh and Glasgow Railway, at or near to the Rat...
Parish of Ratho, and County of Edinburgh; or in that part of the Parish of K...
said County of Edinburgh, or one or other of them, and to terminate within, at, or...
...rgh of Bathgate, in the Parish of Bathgate, and County of Linlithgow, by a jun...
...ded Railway from Airdrie to Bathgate, or otherways. Together also with...
...ways, with all proper Works and Conveniences therewith connected, viz: First, A Bra...
...in the said intended Main Line of Railway, at or near to the Lands or Farm...
...of the Parish of Kirkliston situated within the County of Edinburgh; or at or n...
...of Elliston or Illiston, situated in the Parish of Uphall, and County of Li...
...i of the Parish of Kirkliston situated within the said County of Linlithgow, ...
...r to the Town or Village of Mid Calder, in the Parish of Mid Calder, & Coun...
...point betwixt the Towns or Villages of Mid Calder and East Calder, in the R...
...d Parishes of Kirknewton and East Calder, in the County of Edinburgh; Secon...
...diverge from the said intended Main Line of Railway, at or near to the Fa...
...d Parish of Uphall and County of Linlithgow, to the Freestone Quarries of B...
...the said Parish of Linlithgow, and partly within the said Parish of Up...
...ty of Linlithgow. Third, A Branch Railway to diverge from the said intended Ma...
...a point at or near to the Lands or Farm of Barracks, in the Parish of Livingsto...
...gow aforesaid, or from a point at or near to the Farm of Tailend, in the Par...
...Farm of Deans, in the said Parish of Bathgate, and County of Linlithgow, and...
...at, in, or near to the Village of Whitburn, in the Parish of Whitburn, & Coun...
...l. Fourth, A Branch Railway from or near to the point at which the said in...
...Railway will terminate at Bathgate aforesaid, to, or near to the point at which...
...way to Whitburn will terminate at Whitburn aforesaid, with a connecting Line...
...ed Branch Line to the Village of Blackburn, in the Parish of Livingstone afo...
...her Connecting Line from said Branch Railway to Whitburn, from a point at...
...oss-side, to another point on the said intended Main Line, at or near to the La...
...g Grove, all in the Parish of Bathgate, and County of Linlithgow aforesaid; a...
...y, or some of them, all as shewn on the Plan aftermentioned, or some parts or portio...
...Railways and Branches, and that the Property mentioned in the annexed Sched...
...which I understand you are interested, as therein stated, will be required for th...
...Undertaking according to the lines thereof, as at present laid out, or may be requi...
...usual powers of deviation, to the usual extent of One Hundred Yards on either sid...
...he extent of the limit of deviation delineated on the plans aftermentioned, which...
...he said Act, and will be passed through, in the manner mentioned in such Schedu...
...also beg to inform you, that a Plan and Section of the said Undertaking, with a Book...
...eposited in the Office in Edinburgh of the principal Sheriff Clerk of the Cour...
...fice in Linlithgow of the principal Sheriff Clerk of the County of Linlithgow, on the ...
...nd that Copies of the said Plan and Section, with a Book of Reference thereto, will...
...ection, with the Schoolmaster, if any, and if there be no Schoolmaster, with the Sessio...
...hich your Property is situate, and with the Town Clerk of the Town or Burgh of Ba...
...day of December instant, on which Plans your Property is designated by the numbers s...
...edule. As I am required to report to Parliament, whether you assent to or dissen...
...taking, or whether you are neuter in respect thereto, you will oblige me by writ...
...t dissent, or neutrality, in the form left herewith, and returning the same to me, with...
...re the 8th day of January next, and if there should be any error or misdescription...
...I shall feel obliged by your informing me thereof at your earliest convenience, that I...

Je n'ai pas à te donner le motif de mon retard à t'écrire, n'est-ce pas puisque tu as appris mon accident. Ma jambe était prise sous l'échelle et par le choc j'ai eu les chairs meurtries, la cheville le pied très enflés et tout noirs. Je suis restée au lit une dizaine de jours, ne pouvant appuyer mon pied; puis j'ai commencé à me lever quelques heures ayant

se mariera-t-elle à l'église aussi? Si c'est pour le mois de juin, on devra bientôt faire commencer les préparatifs.

Tu me dis que le vieux château est en vente, c'est le Barry sans doute métairie du bourg. Bel et Brouillets. Alors Mr Jacques ne veut rien conserver à Clermont. Y aura-t-il des acquéreurs?

La Mouline est revenue alors aux anciens propriétaires. La femme Nadou doit être en effet contente de rester là, mais le prix de vente n'égale pas le prix d'achat. Encore s'il lui reste un peu quelque chose.

St Cyr, 28 avril 1934

Ma chère Amélia,

me chercher. La lettre s'est croisée avec celle nous attendons leur Nous te chargeons, ma Aline et moi d'offrir amitiés à Mme Gillet, M. La Louise, Cher Moïse et à tou naissances.

Pour toi, nos plus a toujours la jambe all Maintenant je mar mais les nerfs sont je ne doute pas faci le pied. Enfin puisq du mieux, il faut les mouvements rep leur élasticité. Aline m recommandé de ne à l'échelle, j'ai désob été bien punie.

Je te remercie m Amélia de tous les que tu me donnes Vous avez été témo beau mariage de c'est extraordinaire Clermont. Et M ell

Vos indésirables son Vous allez faire un ce jour-là le lou prendra son calme pas besoin de yeu mettre la paix. être bien débarras

Je n'ai pas à te donner
le motif de mon retard à
t'écrire, n'est-ce pas puisque
tu as appris mon accident.
Ma jambe était prise sous l'échelle
et par le choc j'ai eu les chairs
meurtries, la cheville, le pied
très enflés et tout noirs. Je suis
restée au lit une dizaine de
jours, ne pouvant appuyer mon
pied; puis j'ai commencé à
me lever quelques heures ayant

se mariera-t-elle à l'église
aussi! Si c'est pour le mois
de juin, on devra bientôt faire
commencer les préparatifs.
Tu me dis que le vieux château
est en vente, c'est le Barry sans
doute métairie du bourg, Bul
et Brouillets. Alors Mr Jacques
ne veut rien conserver à
Clermont. Y aura-t-il des
acquéreurs?
La Mouline est revenue alors
aux anciens propriétaires.
La femme Nadou doit être en
effet contente de rester là, mais
le prix de vente n'égale pas le
prix d'achat. Encore s'il lui
reste un peu quelque chose

St Cyr, 28 avril 1934

Ma chère Amélia

me chercher. La lettre
s'est croisée avec celle
nous attendons leur
Nous te chargeons, ma
Aline et moi d'offrir
amitiés à Mme Tillet, à La
Louise, Chez Moïse et à tou
naissances.
Pour toi, nos plus
toujours la jambe
Maintenant je mar
mais les nerfs sont
je ne double pas faci
le pied. Enfin puisq
du mieux, il faut
les mouvements rep
leur élasticité. Aline m
recommandé de ne
à l'échelle, j'ai désob
été bien punie.
Je te remercie ma
Amélia de tous les
que tu me donnes
Tous avez été témo
beau mariage de
c'est extraordinaire
Clermont. Et Mell

Vos indésirables sont
Vous allez faire un
ce jour-là. Le bourg
prendra son calme
pas besoin de
mettre la paix. Je
être bien débarras

Je n'ai pas à te donner
le motif de mon retard à
t'écrire, n'est ce pas puisque
tu as appris mon accident.
Ma jambe était prise sous l'échelle
et par le choc j'ai eu les chairs
meurtries, la cheville le pied
très enflés et tout noirs. Je suis
restée au lit une dizaine de
jours, ne pouvant appuyer mon
pied; puis j'ai commencé à
me lever quelques heures ayant

se mariera-t-elle à l'église
aussi ? Ah c'est pour le mois
de juin, on devra bientôt faire
commencer les préparatifs.

Tu me dis que le vieux Château
est en vente, c'est le Barry sans
doute métairie du bourg, Bel
et Brouillets. Alors M. Jacques
ne veut rien conserver à
Clermont. Y aura-t-il des
acquéreurs ?

La Mouline est revenue alors
aux anciens propriétaires.
La femme Nadom doit être en
effet contente de rester là, mais
le prix de vente n'égale pas le
prix d'achat. Encore s'il lui
reste un peu quelque chose.

St Cyr, 28 avril 1934

Ma chère Amélia,

me chercher. La lettre
s'est croisée avec celle
nous attendons leur
Nous te chargeons, ma
Aline et moi d'offrir
amitiés à Mme Filler, M. Le
Louise, cher Moïse et à to
naissances.

Pour toi, nos plus a...
toujours la jambe al...
Maintenant je mar...
mais les nerfs sont
je ne doute pas fac...
le pied. Enfin puis...
du mieux, il faut
les mouvements re...
leur élasticité. Aline m'
recommandé de ne...
à l'échelle, j'ai désob...
été bien punie.

Je te remercie m...
Amélia de tous les
que tu me donnes
Vous avez été tém...
beau mariage de...
c'est extraordinaire
Clermont. Et M. ell...

Vos indésirables sont i...
Vous allez faire un...
ce jour-là le bou...
prendra son calme...
pas besoin de gen...
mettre la paix. Ve...
être bien débarras...